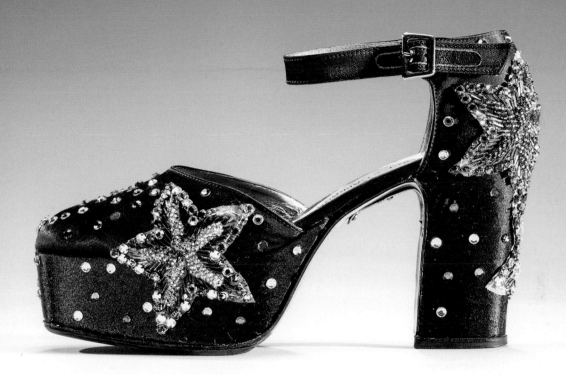

BATA SHOE MUSEUM

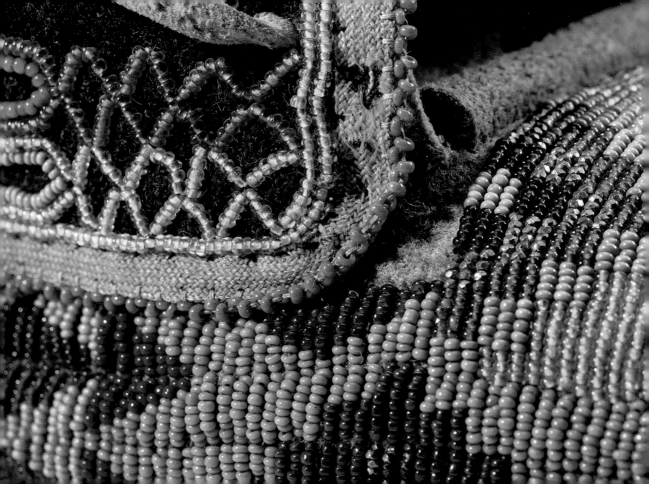

BATA SHOE MUSEUM

ELIZABETH SEMMELHACK

PHOTOGRAPHY BY RON WOOD

introduction

From a global obsession with sneakers to the complicated politics of the high heel, footwear has increasingly become the focus of significant cultural commentary. While this attention to shoes may seem like a recent development, footwear has been a key feature of dress around the world for millennia and has been used to express a wide range of social ideas, including those regarding gender and status. Since the inception of the Bata Shoe Museum in 1995, its mission has been to explore and illuminate these multifaceted histories of culture and society through footwear. Shoes bring us into startlingly close proximity with people from distant times and places and are a surprisingly effective entry point into an understanding of the economics, politics, and values of the societies in which they were made and worn, revealing sometimes elusive or overlooked characteristics of a culture.

FIRST STEPS

In 1946, at the age of nineteen, Swiss native Sonja Ingrid Wettstein married Czech-born Thomas J. Bata and joined him in Canada, where he had moved in 1939, just as the Second World War began, to reestablish his father's shoe manufacturing empire. The nationalization of Bata's Czechoslovakia holdings under Communist rule, after World War II, allowed the Batas to focus on the company's wide-ranging international manufacturing and distribution channels outside of Europe. As part of this undertaking, Sonja Bata traveled the world with her husband, which sparked a fascination with the incredible diversity of footwear she discovered in the cultures she was

PAGE 1 Dolce & Gabbana (page 40).

PAGE 2 Detail, Nêhiyawak (page 48).

OPPOSITE A glimpse into artifact storage at the Bata Shoe Museum, 2019.

4

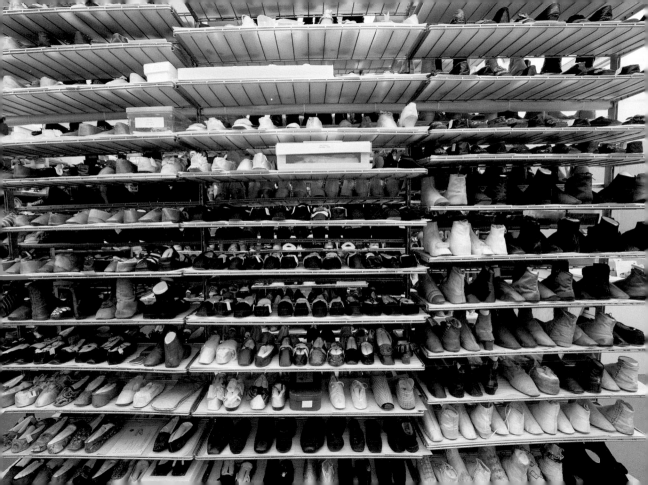

exposed to. Her first collecting efforts consisted of acquiring examples of local footwear to serve as inspiration for Bata shoe designers, but as her collection grew, she became increasingly interested in footwear items as cultural objects. She was intrigued by their many facets, from how they were made to how they were worn. As a result, she decided to shift her focus. While she continued to collect contemporary footwear from diverse regions and cultures, she also began to collect historical examples seriously. By 1979 her holdings numbered in the thousands, and the Bata Shoe Museum Foundation was established as an independent entity committed to sponsoring field research and publishing findings.

BUILDING A MUSEUM

In the mid-1980s, Sonja Bata decided to build a museum in the heart of downtown Toronto dedicated to telling the stories of humanity through footwear. Her deep appreciation of architecture and her vision for the museum called for a bold approach, so she turned to acclaimed Canadian architect Raymond Moriyama and commissioned him to create a "small gem of a museum." Moriyama was intrigued by the idea of a museum dedicated to footwear, and he decided to model the new building on the shape of a shoebox. He continued the theme throughout the building, incorporating many subtle footwear-referencing details that spoke to the purpose of the building. The building is clad in a warm fine-textured limestone that was chosen for its resemblance to leather, and the impressive floating staircase that cuts through the open atrium features holes punched into the risers, allowing visitors to see the shoes of those using the stairs.

When the museum opened on May 6, 1995, it attracted a great deal of curiosity, as it was the only shoe museum in North America and one of only a small number worldwide. At that time, there had been little formal research on the subject of footwear, but over the years, the museum's reputation as a center for scholarship and insight has grown, and it continues to expand today. In the years since the museum's opening the collection has also grown, and today it includes more than 14,000 shoes and footwear-

related artifacts spanning 4,500 years of history. This extraordinary collection allows the museum to mount innovative and original exhibitions regularly, publish widely, and develop engaging educational programs.

THE SHOES

The shoes themselves have entered the collection in a variety of ways. Field research has permitted the museum to collect contemporary examples of footwear made by living designers and artisans as part of the study and documentation of shoemaking processes. Auction houses and dealers are another major source of rare historical artifacts, and generous private donations of footwear and footwear-related artifacts and documents are yet another extremely important means of growing the collection.

Field research was an especially great source of pride for Sonja Bata, who appreciated that it brought to the collection not only new artifacts, but also significant primary research and cultural context seldom attached to museum artifacts. By working directly with contemporary makers, she challenged the misconception that some cultures are "timeless" and isolated from both internal cycles of fashion and cross-cultural influences. Museum-sponsored research has included trips to all the circumpolar regions of the world, including Greenland, Canada, the United States, Russia, and Sápmi, the homeland of the Sámi people, which stretches across northern Scandinavia from Norway to Russia. With each field trip to the Arctic regions, the holdings have grown, and the museum now houses the largest collection of circumpolar footwear in the world.

Research funded by the foundation has also been conducted in Nepal to document traditional boot-making by the Tibetan diaspora; in India to study *jutti* and *chappal* making; and in Mongolia to study the making of *gutal*. Additional research has also been undertaken in Europe and the United States to study many areas, including the impact of the industrialization of shoe manufacturing on workers and consumers in the nineteenth century; the work of designer Roger Vivier in France; the introduction of the heel into Western fashion in Hungary and Austria; and contemporary sneaker culture in the

United States and Europe. The museum collection itself is also the focus of constant study and research.

All objects that enter the museum collection are cared for assiduously. Their condition is assessed and they are conserved before being secured in specially designed artifact storage rooms. The museum is privileged to have a senior conservator who is arguably unrivaled in the conservation of historic footwear. It is the policy and practice of the Bata Shoe Museum to carefully and ethically conserve artifacts rather than to "restore" them, an activity that can remove evidence of use. The museum is interested in the information that can be gleaned from the traces left by the wearer along with evidence of the environment through which the person walked. These details can be as important to the historian and researcher as the materials and construction of the shoe itself. An unusual and popular feature of the museum's conservation lab is a set of long glass windows that permits visitors to watch as footwear is being conserved.

EXHIBITING FOOTWEAR

With less than 3 to 4 percent of the collection on view at any given time, changing exhibitions are an important way of showing the breadth of the collection, as well as a means of engaging the audience with new questions. Architect Moriyama designed three special exhibition galleries, each of which is a "blank box," allowing the gallery interiors to be reimagined and transformed for each new show. In just over two decades, the research and collecting on behalf of the museum have led to a schedule of ambitious original exhibitions, many of which have been the first in the world dedicated to specific types of shoes. Notable among these are *Our Boots: An Inuit Woman's Art* (1995), which focused on Canadian Inuit women's artistry and skill (pages 216–17); *Every Step a Lotus: Shoes in the Lives of Chinese Women from Late Imperial China* (2001), which reconsidered the role of foot-binding in imperial China; *Heights of Fashion: A History of the Elevated Foot* (2001), the first exhibition on the history of the high heel; and *On a Pedestal: Renaissance Chopines to Baroque Heels* (2009), the first exhibition on the history of the Renaissance chopine (pages 60–61). Other innovative

exhibitions include: *Out of the Box: The Rise of Sneaker Culture* (2013); *Fashion Victims: The Pleasures and Perils of Dress in the Nineteenth Century* (2014); *Standing Tall: The Curious History of Men in Heels* (2015); and *The Great Divide: Eighteenth-Century Footwear and the Enlightenment* (2019).

Over the years, these exhibitions and their companion publications have demonstrated that footwear offers a fascinating and often surprisingly illuminating means of stepping into cultures both past and present. Because shoes are designed to meet the cultural desires of the moment in which they are made, they not only capture the material and technological aspects of those times, but also document the tastes, aspirations, and assumptions held by a people in a given moment or place. Because visitors already have a direct and personal understanding of footwear, these insights into different periods and perspectives are relevant to them. They can also lead to revelations when long-standing assumptions are challenged. The museum is dedicated to expressly encouraging visitors to consider how their own footwear choices reflect the larger social structures in which they live.

THE FUTURE

What started as a small private collection has been transformed into an internationally celebrated museum with a spectacular collection of footwear and a twenty-five-year history of supporting wide-ranging original research. With her eye on the future, Sonja Bata ensured that the museum would continue to flourish after she passed away. Not only is the collection growing, but the museum's reach continues to expand through an ever-increasing number of publications and exhibitions, as well as engaging public programs and an online presence.

This book, published in honor of the Bata Shoe Museum's twenty-fifth anniversary, offers a glimpse into this remarkable collection. Sonja Bata's dedication to scholarship was matched only by her deep appreciation for the beauty of the footwear she collected. We share with you many of her (and our) favorites in the pages that follow.

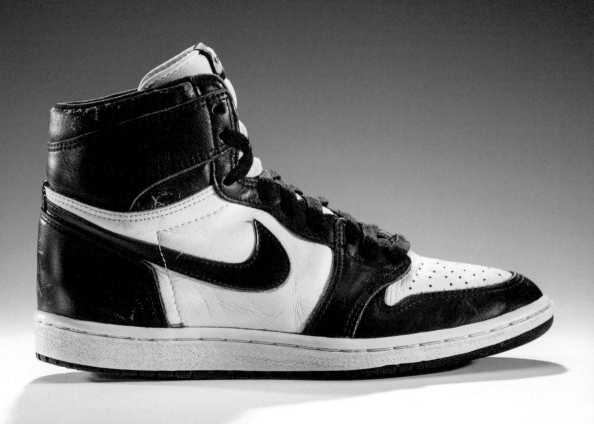

AMERICAN · DESIGNED BY PETER MOORE FOR NIKE · 1985 · GIFT OF CHRIS COCKERHAM

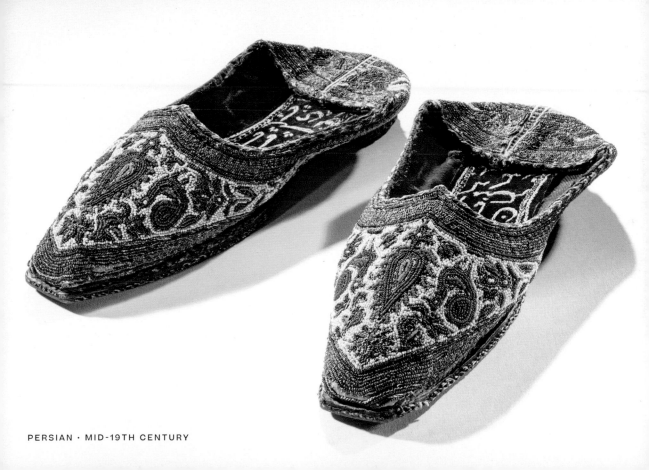

PERSIAN · MID-19TH CENTURY

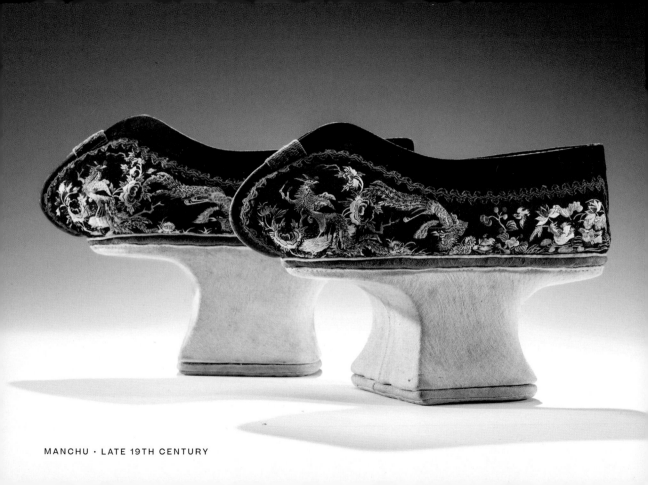

MANCHU · LATE 19TH CENTURY

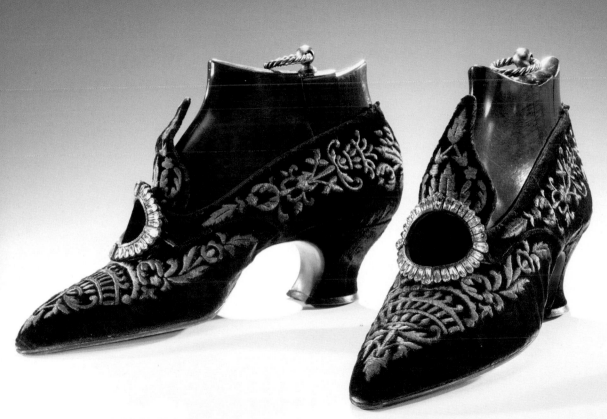

FRENCH · CREATED BY PIETRO YANTORNY · 1920s · GIFT OF MARY WEINMANN

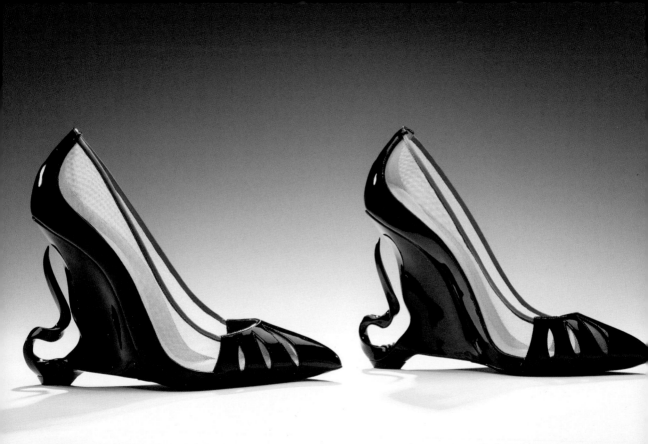

FRENCH · DESIGNED BY CHRISTIAN LOUBOUTIN · 2014 · GIFT OF CHRISTIAN LOUBOUTIN

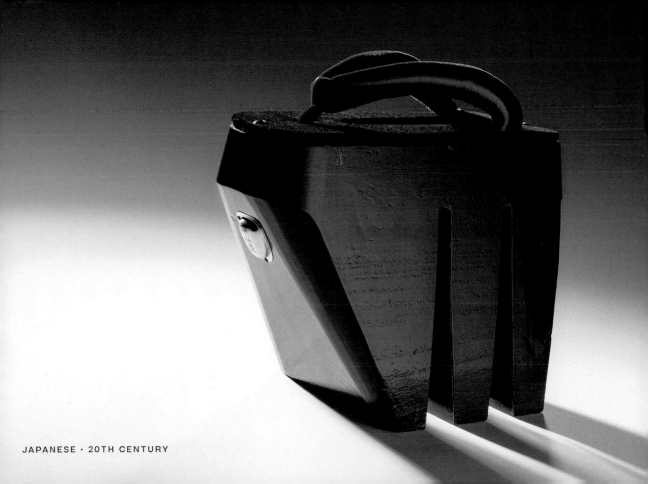

JAPANESE · 20TH CENTURY

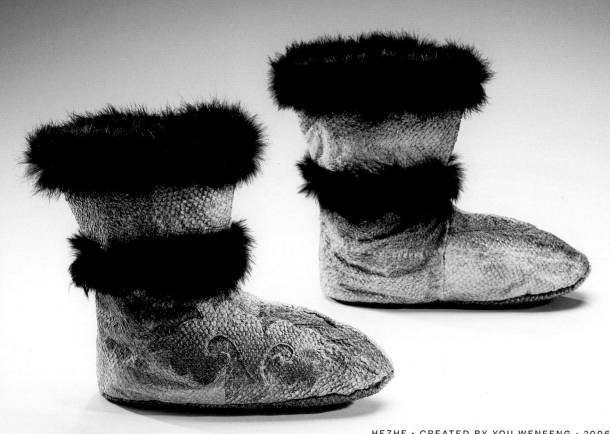

HEZHE · CREATED BY YOU WENFENG · 2006

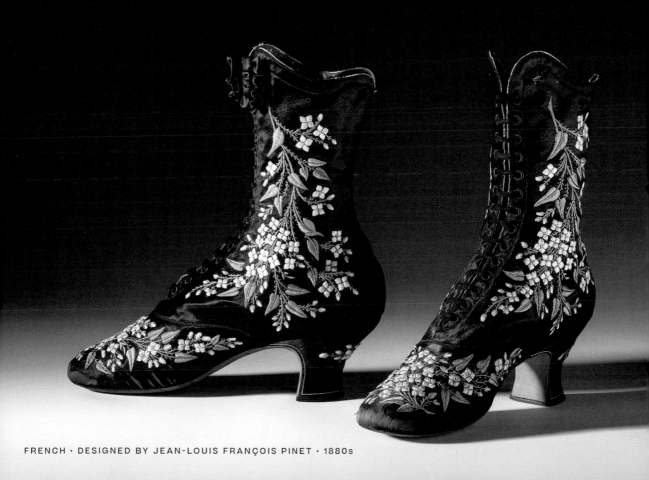

FRENCH · DESIGNED BY JEAN-LOUIS FRANÇOIS PINET · 1880s

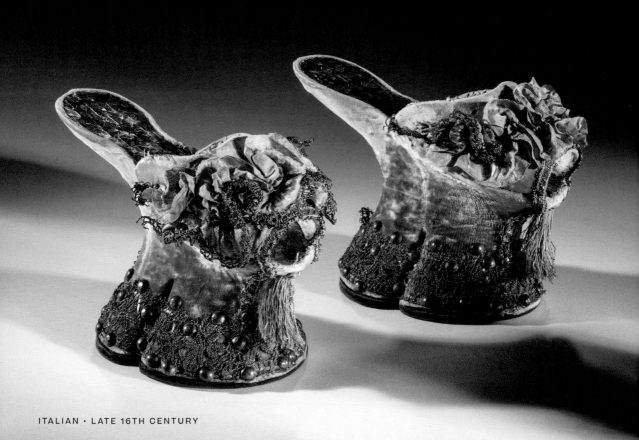

ITALIAN · LATE 16TH CENTURY

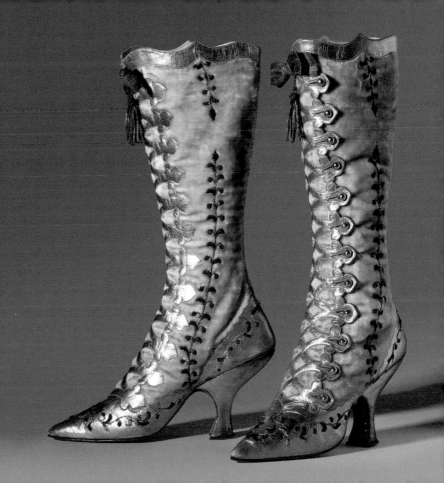

SWISS OR GERMAN · 1890s

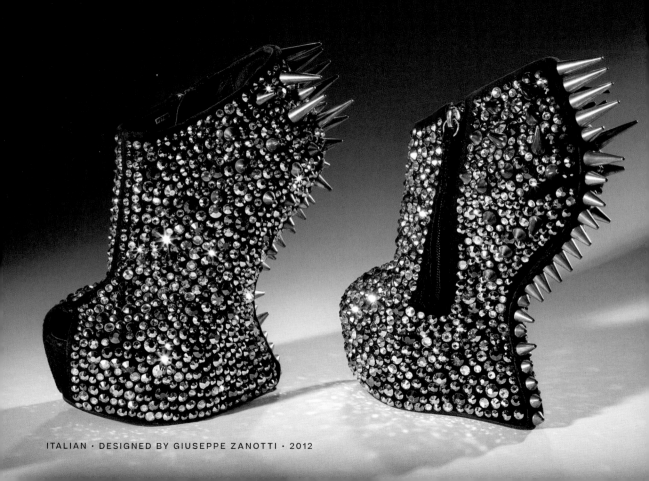

ITALIAN · DESIGNED BY GIUSEPPE ZANOTTI · 2012

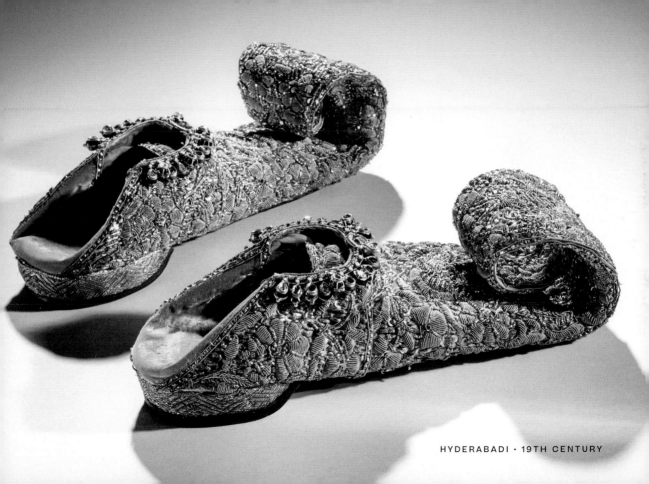

HYDERABADI · 19TH CENTURY

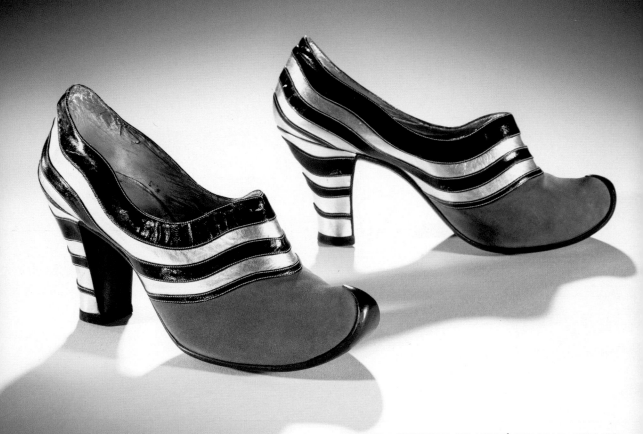

FRENCH · DESIGNED BY ANDRÉ PERUGIA · 1925–27

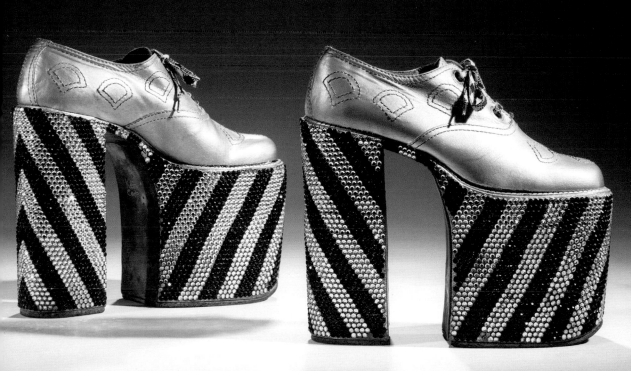

ITALIAN · DESIGNED BY FERRADINI · 1972–75

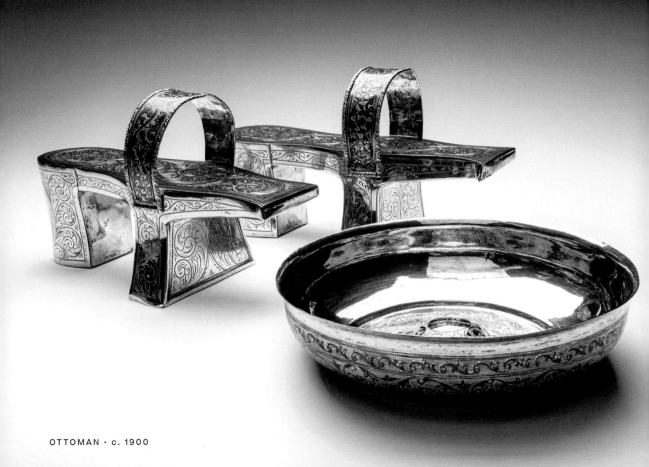

OTTOMAN · c. 1900

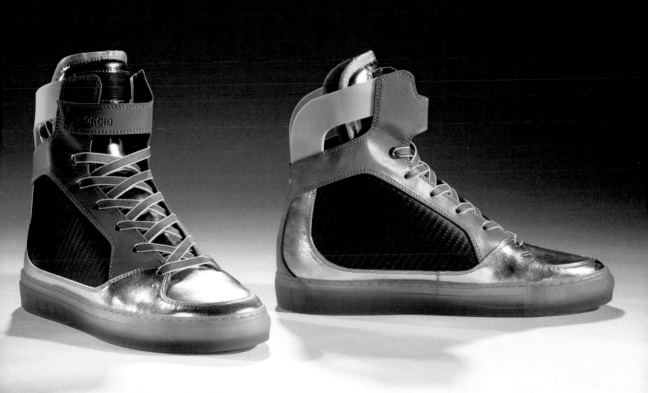

AMERICAN · DESIGNED BY ANDROID HOMME FOR GE · 2014 · GIFT OF GE

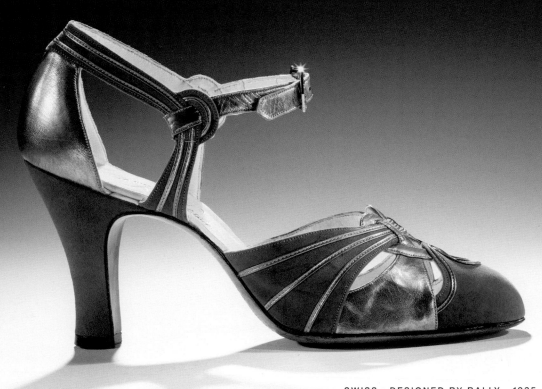

SWISS · DESIGNED BY BALLY · 1935–36

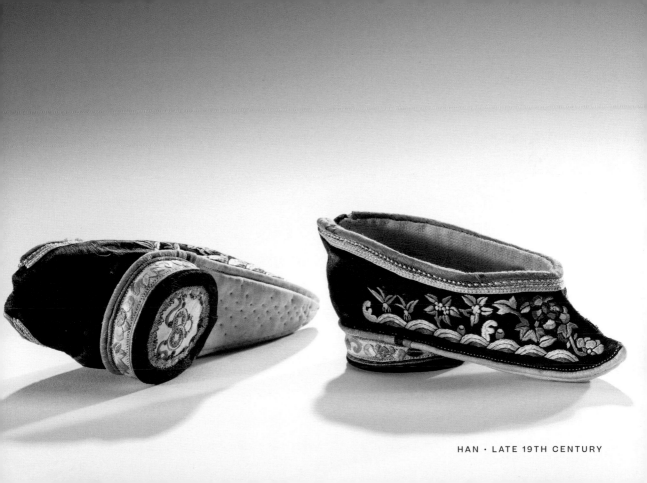

HAN · LATE 19TH CENTURY

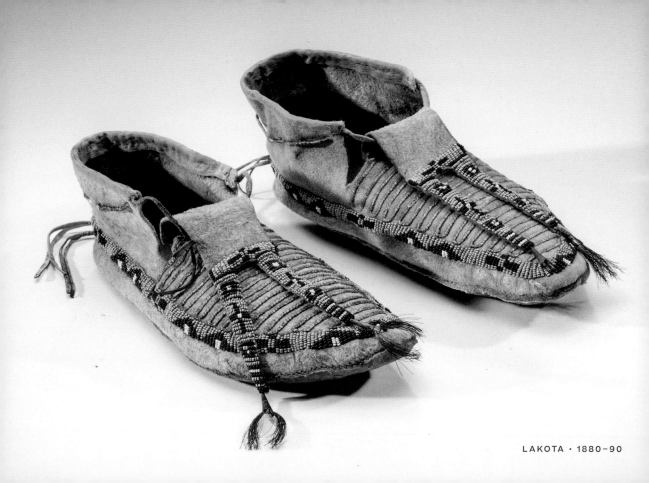

LAKOTA · 1880–90

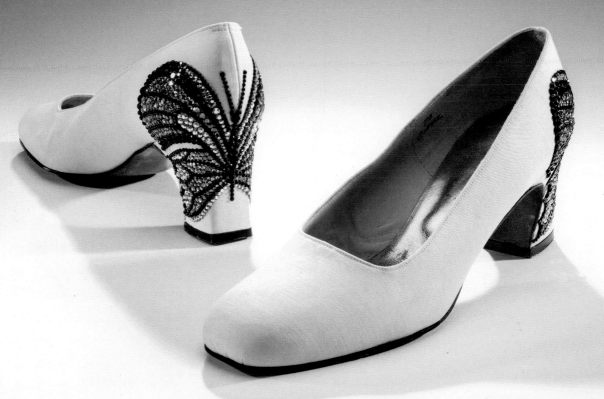

AMERICAN · DESIGNED BY BETH LEVINE · 1967–69

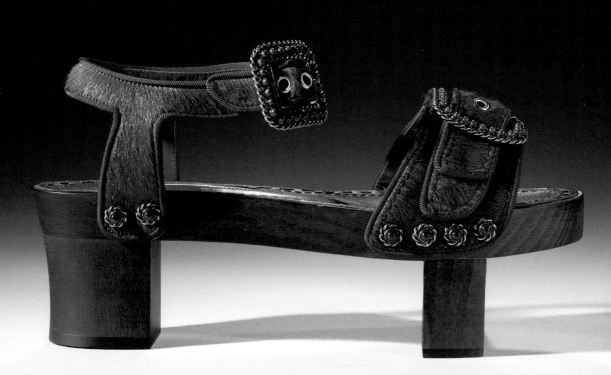

ENGLISH · DESIGNED BY MANOLO BLAHNIK · 2016 · GIFT OF MANOLO BLAHNIK

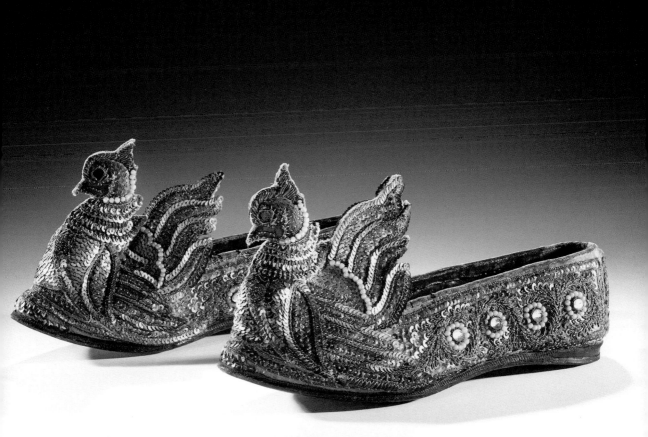

MYANMARESE · 19TH CENTURY

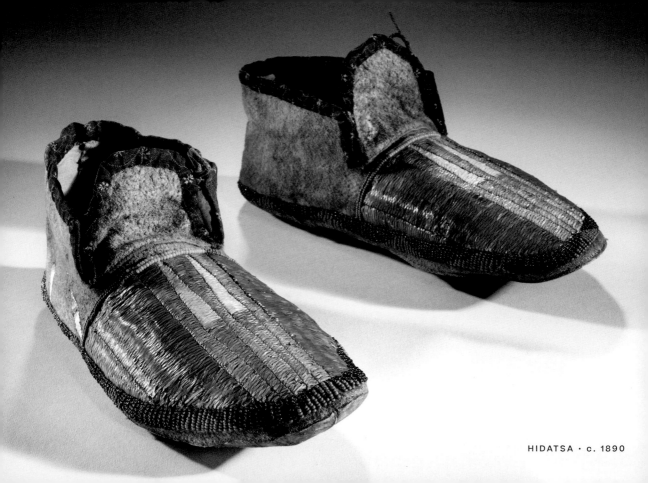

HIDATSA · c. 1890

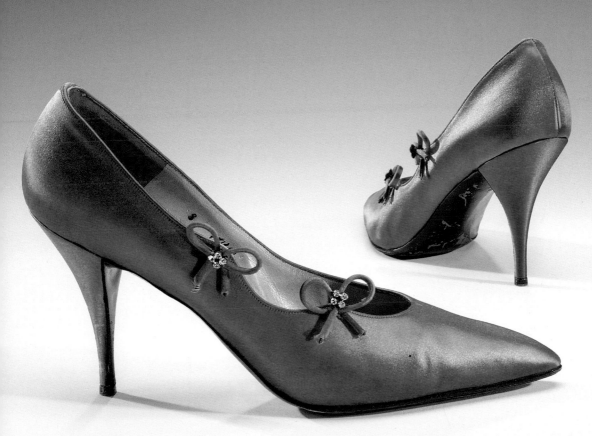

FRENCH · DESIGNED BY ROGER VIVIER FOR CHRISTIAN DIOR · 1962

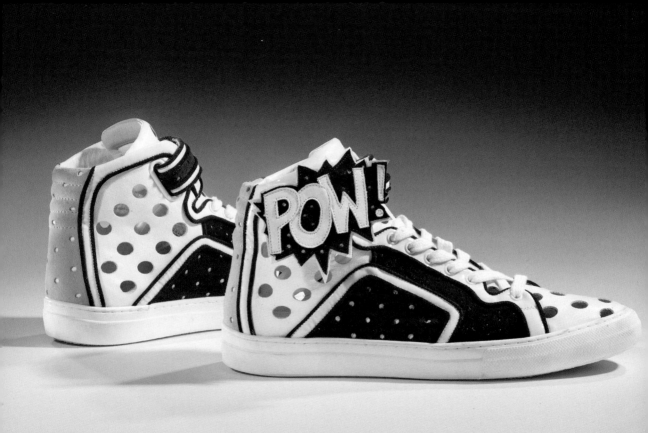

FRENCH · DESIGNED BY PIERRE HARDY · 2011 · GIFT OF PIERRE HARDY

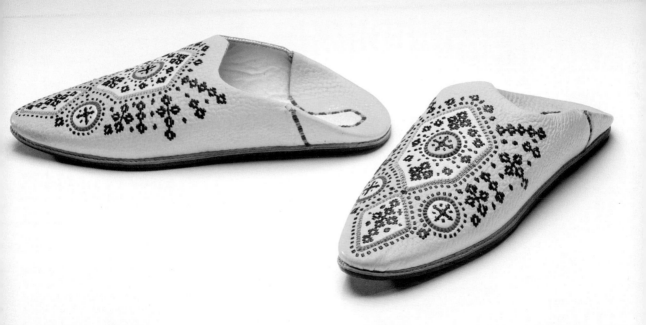

MOROCCAN · 1980s

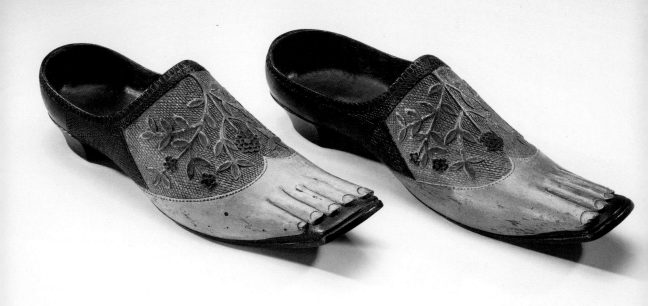

DUTCH · LATE 19TH CENTURY

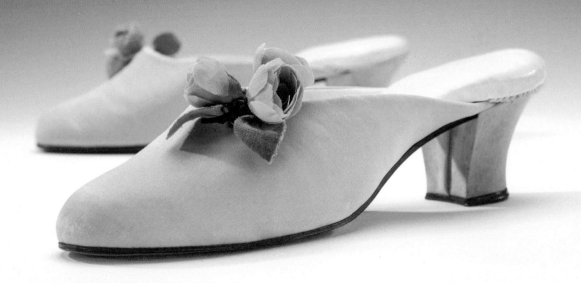

ITALIAN · 1920s

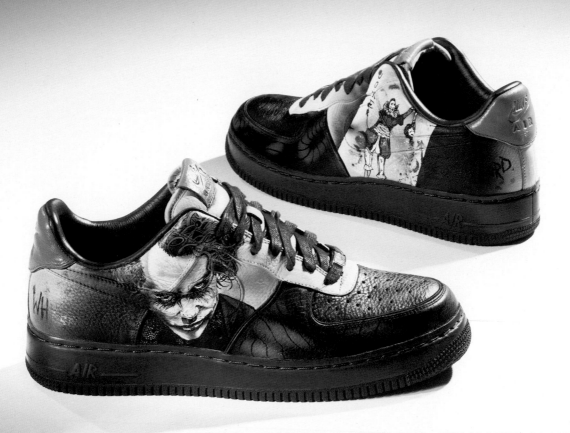

AMERICAN · CUSTOMIZED BY MACHE · 2009 · GIFT OF DANIEL GAMACHE

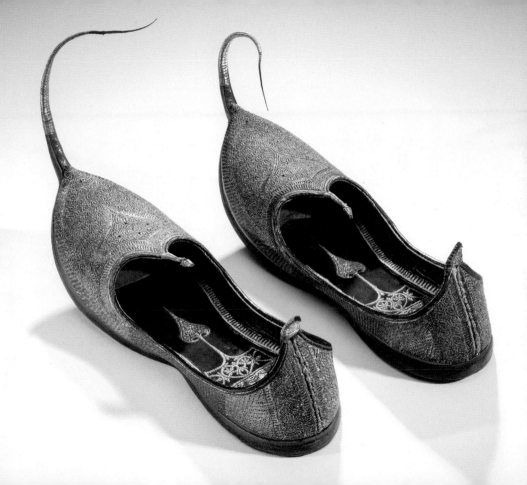

INDIAN · 1950

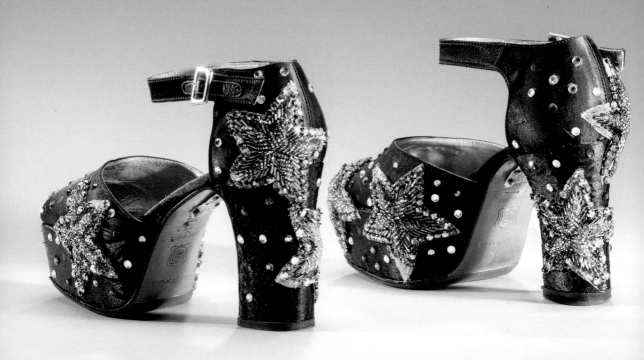

ITALIAN · DESIGNED BY DOLCE & GABBANA · MID-1990s

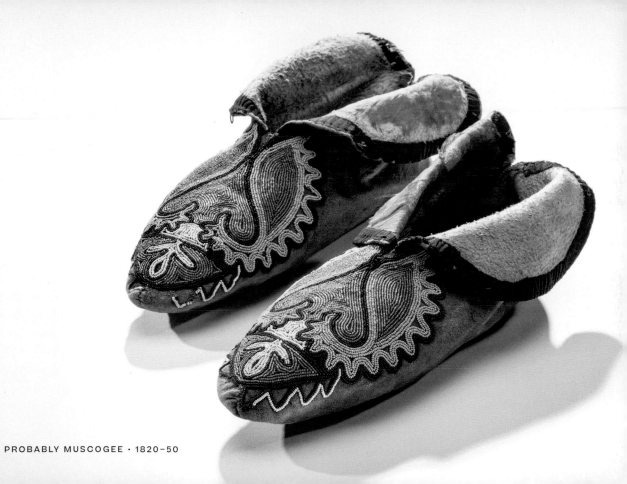

PROBABLY MUSCOGEE · 1820–50

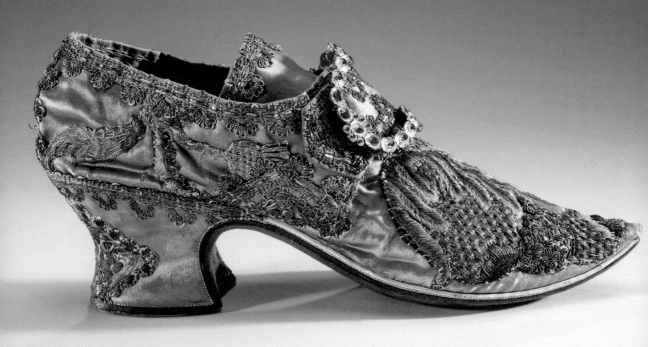

POSSIBLY SCOTTISH · 1740s

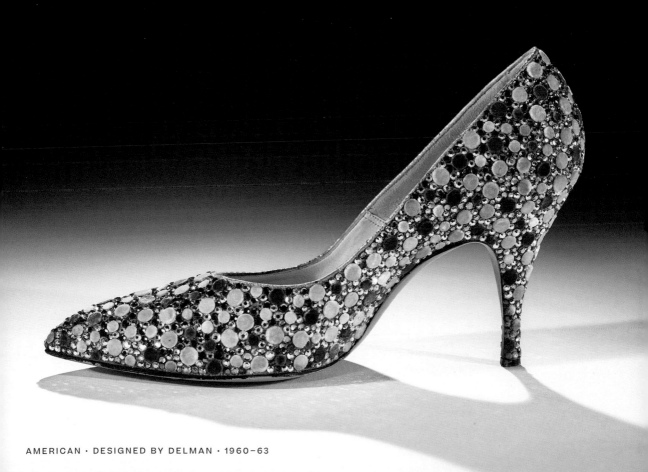

AMERICAN · DESIGNED BY DELMAN · 1960–63

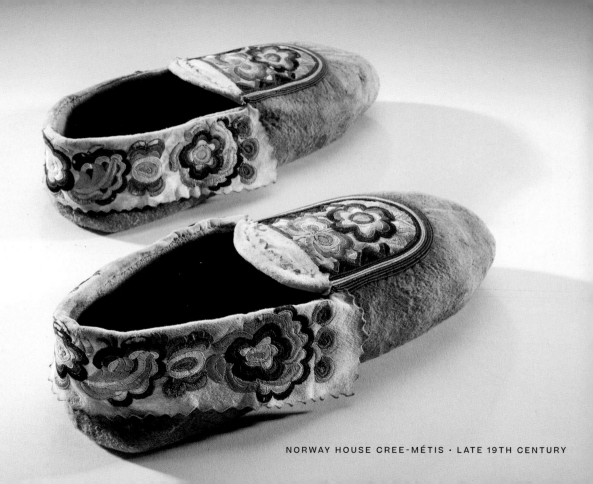

NORWAY HOUSE CREE-MÉTIS · LATE 19TH CENTURY

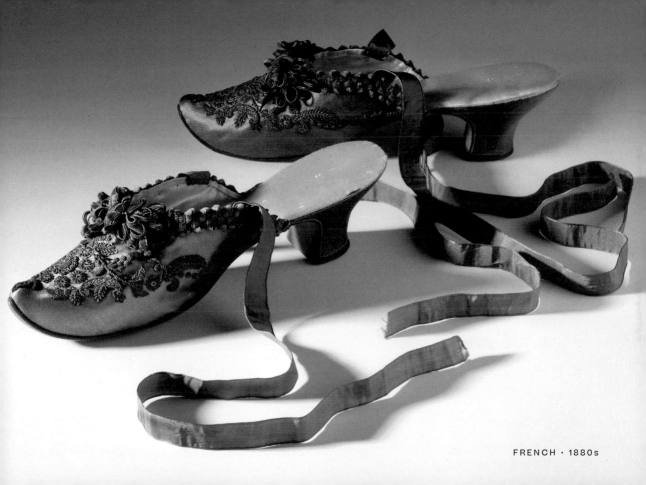

FRENCH · 1880s

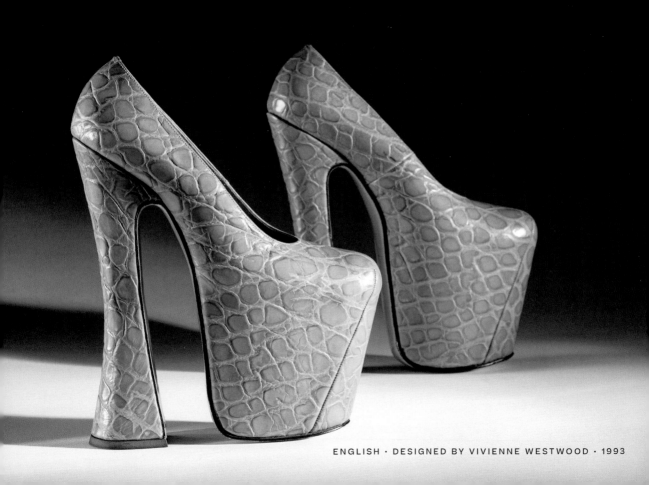

ENGLISH · DESIGNED BY VIVIENNE WESTWOOD · 1993

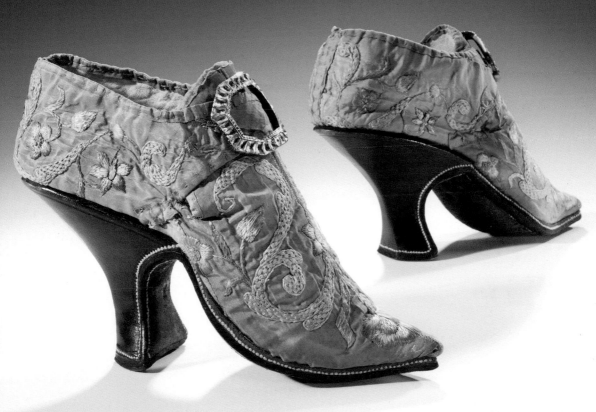

ITALIAN · 1700–20

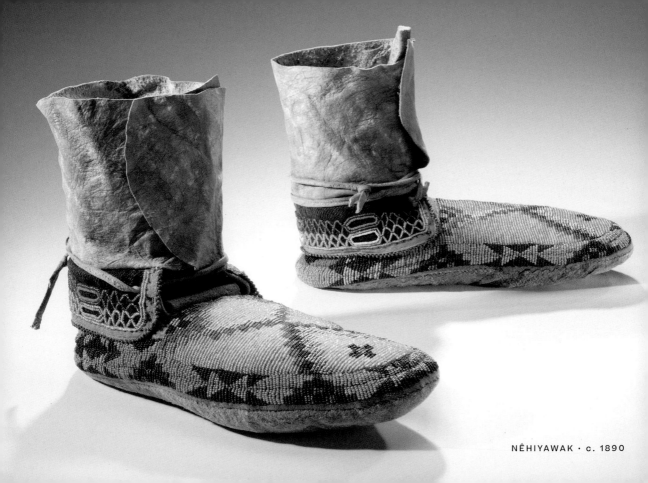

NÊHIYAWAK · c. 1890

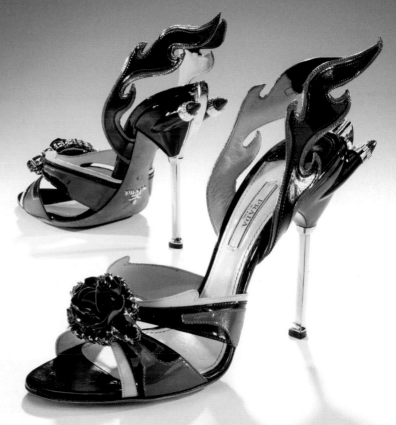

ITALIAN · DESIGNED BY PRADA · 2012 · GIFT OF PRADA

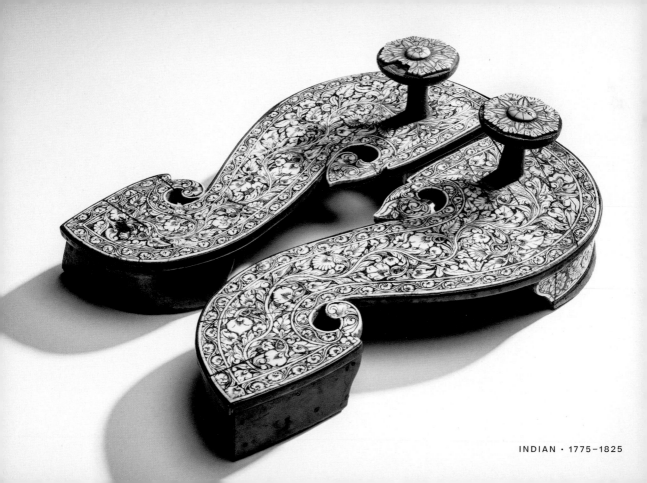

INDIAN · 1775–1825

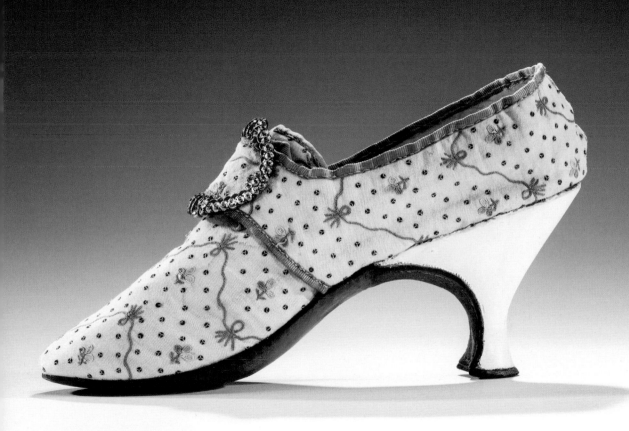

FRENCH · 1770–80

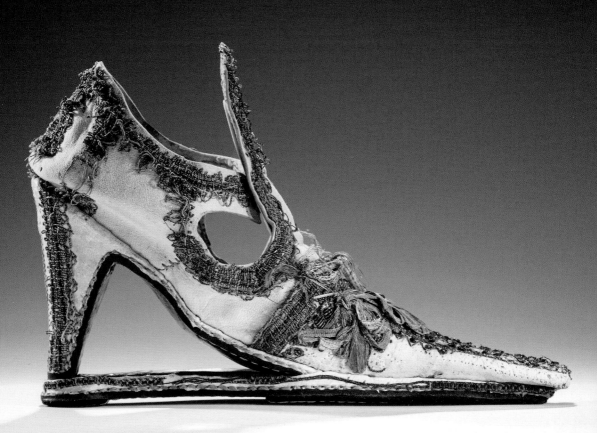

PROBABLY ITALIAN · 1660s

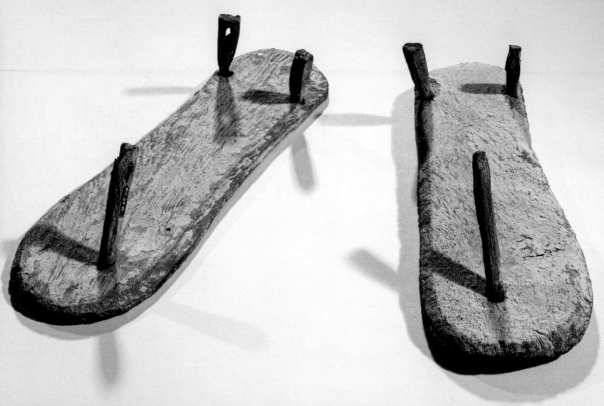

EGYPTIAN · 2565–2278 BCE

acknowledgments

This beautiful book was published in celebration of the Bata Shoe Museum's twenty-fifth anniversary. It owes its very existence to my mother, Sonja Bata, founder of the Bata Shoe Museum Foundation and the visionary behind its extraordinary collection. Her profound commitment to the history of footwear and design excellence continues to inspire.

Like the creation of the museum, this book could not have happened without the support and hard work of numerous people, each of whom deserves sincere thanks. Firstly, I would like to express my deep gratitude to Elizabeth Semmelhack, creative director and senior curator of the Bata Shoe Museum. Elizabeth's breadth of knowledge and compelling insights are evident on every page. This special publication reflects her passion for the collection. We are most grateful to Ron Wood for his spectacular photography, capturing the essence of each artifact. Tremendous thanks to our conservator, Ada Hopkins; collections manager, Suzanne Petersen; and assistant curator and manager of exhibitions, Nishi Bassi, for their tireless work on this project and their dedication to the museum. I also want to thank Annie Wood and Alex Lo for their assistance. Great thanks is also extended to Charles Miers, publisher of Rizzoli International Publications, for championing this project; to Andrea Danese for her wonderful editing; and to Sarah Gifford, whose beautiful book design has made this a volume to treasure.

I would also like to acknowledge the board of the Bata Shoe Museum Foundation for their enthusiasm and support.

To further honor its founder, the museum has chosen to use the Sonja Bata Memorial Fund to fund the creation of this book. We know that Sonja Bata would be deeply touched by each donation.

CHRISTINE BATA SCHMIDT

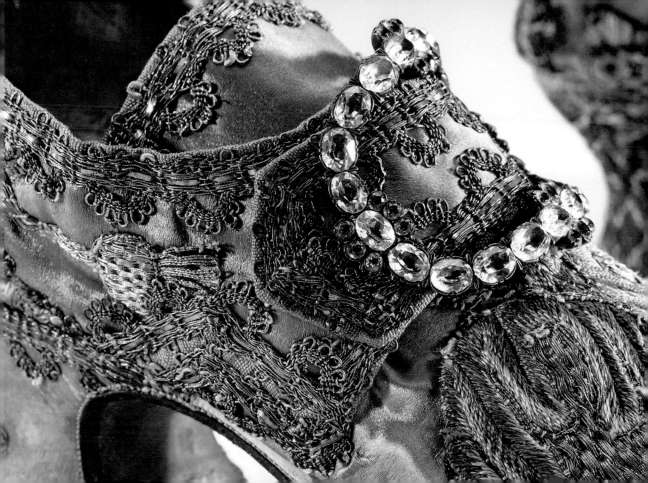

PREVIOUS PAGE Detail, possibly Scottish (page 42).
CASE FRONT Poworama sneakers (page 34).
CASE BACK Manchu *mati* (page 12).

First published in the United States of America in 2020 by
Rizzoli Electa, A Division of
300 Park Avenue South
New York, NY 10010
www.rizzoliusa.com

Images and text copyright © 2020 Bata Shoe Museum, Toronto
Text: Elizabeth Semmelhack
Photography: Ron Wood

Publisher: Charles Miers
Associate Publisher: Margaret Rennolds Chace
Editor: Andrea Danese
Design: Sarah Gifford
Production Manager: Barbara Sadick
Managing Editor: Lynn Scrabis

Printed in Hong Kong

2020 2021 2022 2023 / 10 9 8 7 6 5 4 3 2 1

ISBN: 978-0-8478-6786-8
Library of Congress Control Number: 2019957677

Visit us online:
Facebook.com/RizzoliNewYork
Twitter: @Rizzoli_Books
Instagram.com/RizzoliBooks
Pinterest.com/RizzoliBooks
Youtube.com/user/RizzoliNY
Issuu.com/Rizzoli